CALIFORNIA'S
FALL COLOR

CALIFORNIA'S
FALL COLOR

A Photographer's Guide to Autumn in the Sierra

G Dan Mitchell

To Patricia Emerson Mitchell, partner in my search for beauty

© 2015 by G Dan Mitchell

Library of Congress Cataloging-in-Publication Data

Mitchell, G. Dan.
 California's fall color : a photographer's guide to autumn in the Sierra / G. Dan Mitchell.
 pages cm
 Includes bibliographical references.
 ISBN 978-1-59714-317-2 (pbk. : alk. paper)
 1. Landscape photography--Sierra Nevada (Calif. and Nev.) 2. Fall foliage--Sierra Nevada (Calif. and Nev.) 3. Sierra Nevada (Calif. and Nev.)--Description and travel. I. Title.
 TR660.M58 2015
 779'.36097944--dc23

 2015005802

Cover Photo: G Dan Mitchell
Book Design: Ashley Ingram
Maps: Ben Pease Cartography

Orders, inquiries, and correspondence should be addressed to:
 Heyday
 P.O. Box 9145, Berkeley, CA 94709
 (510) 549-3564, Fax (510) 549-1889
 www.heydaybooks.com

Printed in East Peoria, IL by Versa Press Inc.

10 9 8 7 6 5 4 3 2 1

CONTENTS

Introduction 7

Autumn in the Sierra Nevada 11

Where to Find Fall Color 17

 🌿 High-Elevation Aspens 18

 🌿 US Route 395 and the Eastern Sierra 18

 🌿 Passes and Trans-Sierra Routes 43

 🌿 Lake Tahoe and Hope Valley 52

 🌿 Aspens and Snow 64

 🌿 Fall Color in Yosemite Valley 68

How to Photograph Fall Color 87

 🌿 Embracing the Unexpected 96

Etiquette and Respect 105

Conclusion 111

Resources and Acknowledgments 114

About the Author 116

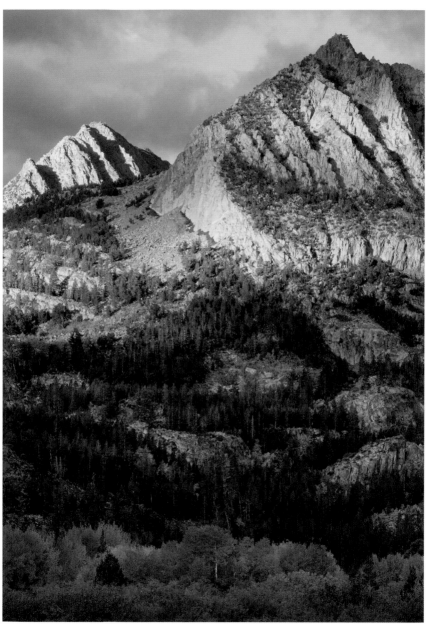

Morning light on colorful autumn aspens below the alpine ridges and peaks at North Lake

INTRODUCTION

California's Sierra Nevada holds many treasures, and one of them is autumn. The attractions of summer (camping, hiking, fishing) and winter (skiing!) are better known, but many Sierra aficionados will tell you that fall is their favorite season. This is a time of moderate temperatures, blue-sky days tempered by the arrival of the first Pacific weather systems, far less crowding in popular areas, beautiful autumn light, and no mosquitos!

It is also the fall color season, a time of surprisingly beautiful displays all around the Sierra, from the deciduous trees and grasslands of the foothills and valleys in the west, through the sometimes subtle colors of the high alpine regions, and over to the cottonwood trees of the east side, culminating in spectacular displays of aspen color that stretch from the eastern escarpment down into the high desert valleys beyond.

In the same way that newcomers may regard California summers as arid and dry—until they come to see those dry and golden hills as beautiful—visitors familiar with the famous New England fall color initially imagine that what the Sierra offers is less compelling. However—and if

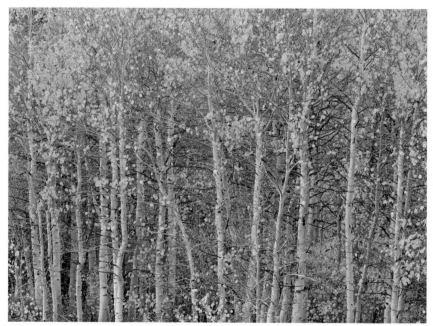

Bright yellow autumn leaves festoon a dense aspen thicket along Bishop Creek near South Lake.

you know the Sierra you probably know this already—once you learn where *and how* to see the beauties of autumn in the Sierra, you will begin to find them everywhere, you'll come to love them, and you may feel compelled to return every year.

The goal of this book is to equip you to discover fall color in the Sierra Nevada. Through the eyes of a landscape photographer and longtime Sierra adventurer, we'll look at:

- The autumn color transition, from the first hints in late summer through low-elevation color in early November

- Timing and location of fall color in popular areas, including the east side of the Sierra, the Tahoe region, Yosemite Valley, and the Sierra foothills

- Discovering your personal favorite fall color locations

- Tips and techniques for photographing fall color

- Many photographs of Sierra Nevada fall subjects to inspire you

If you are new to fall in the Sierra, expect to discover some wonderful surprises. If you already know about the beauties of the autumn season in these mountains, enjoy the long and rewarding process of new discovery and deeper knowledge of the range. And now, let's go exploring!

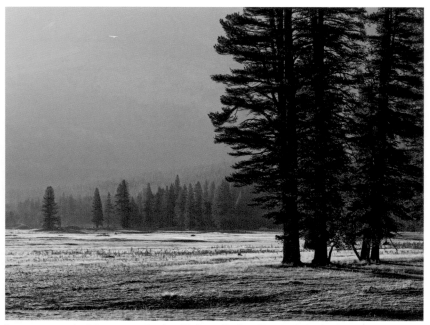

Late-summer morning light on trees at the edge of Tuolumne Meadows, Yosemite National Park

AUTUMN IN THE SIERRA NEVADA

One of the great things about fall conditions in California is that they are often sustained over a surprisingly long period. The first hints of the changing season may come in early September at the higher elevations of the Sierra Nevada—even earlier in a dry year if you know what to look for. In the lowland and coastal areas, the final vestiges of fall color may not be gone until December.

In the Sierra, summer is a short and almost hyper-active period of sudden, rapid growth. This period may be measured in weeks, and in a typical year things slow down noticeably by the end of August. As autumn approaches, the atmosphere becomes softer and more luminous, the morning air gets colder, and the way sound carries across the landscape changes.

Lake levels drop, rivers slow, and some creeks dry up. Wildflowers wilt and go to seed. Meadow grasses go dormant and corn lily plants begin to turn golden yellow. Large meadows turn brown, and the brown begins to become golden. Bilberry plants create a brilliant red carpet in forest clearings and at lake edges when the light is just right. Yellow leaves appear on willow plants along creeks and rivers. Marmots and squirrels busy themselves with the tasks of fattening up and stashing away stores for winter.

As the days become shorter and the nights longer, the transition accelerates, and the main High Sierra fall show begins. Aspen leaves become lime green, then suddenly change to yellow, gold, orange, and red. The mechanism behind the change in leaf color is a bit counterintuitive. We might imagine that red and yellow are being *added* to the leaves, but the leaves are actually losing and no longer replacing the chlorophyll that produced the green color of summer growth. When the green chlorophyll is gone, other colors that were always present in the leaves come to the fore.

Golden late-season corn lily plants at Half Moon Meadow, Yosemite National Park

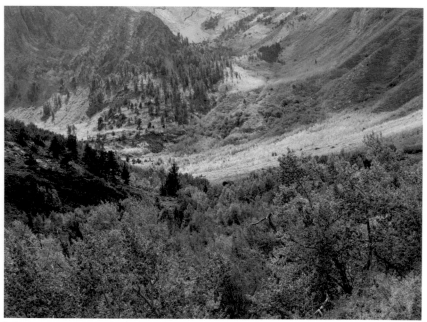

Early aspen color: mid-September in McGee Canyon

Sierra Nevada aspen color peaks in the first half of October. Various factors affect the timing, including decreasing light as days shorten, cooler temperatures, the amount of moisture available to the trees (drier areas and years may accelerate color change), and whether winds blow the leaves down. A cold snap is thought to accelerate color change in leaves close to changing. Elevation makes a difference. The first trees change color at higher elevations and the color works its way down as the season proceeds; there can be fine aspen color at the base of the Eastern Sierra after the middle of the month. Lower-elevation color from cottonwoods, maples, oaks, dogwoods, and other plants usually comes a bit later, perhaps from the last part of October on into November. Latitude also makes a difference. Since moving north is like gaining elevation, the change can come earlier in the Northern Sierra.

With all of these factors at work, the timing of color varies depending upon location. Given its elevation and climate variations, you can find fall color over a very long period of time in the Sierra Nevada!

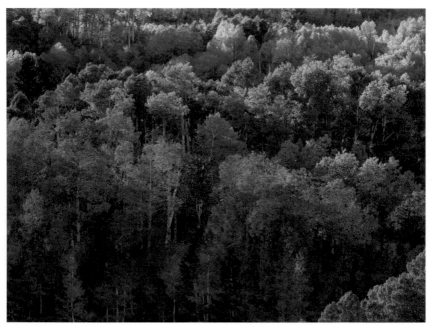

Colorful Eastern Sierra aspen groves along US 395 at Conway Summit

WHERE TO FIND FALL COLOR

There are many, many places to find beautiful autumn color in the Sierra. Some are quite well known and accessible, while others are off the beaten track. In the following descriptions you will find enough information to keep you busy for many days, or even weeks. Ardent explorers may also find hints that lead them to uncover still more color. It is not possible to describe every location here, nor would it be responsible to do so. A little mystery is a good thing, and to share everything would diminish your opportunities to discover your own special places.

Keep in mind that autumn color can be a fickle thing. You might want to photograph a particular grove in a specific canyon, but that grove's color may only be at its best for a few days that don't coincide with your visit. Watch local conditions closely and try to remain flexible.

If the color isn't great in the place you were aiming for, it probably is good somewhere else nearby.

And don't forget that high elevations can experience true winter conditions during aspen season if an early storm comes through. Conditions can change quickly—so check weather forecasts and be prepared for snow.

HIGH-ELEVATION ASPENS

Color comes first to the higher regions of the Sierra Nevada. In general, there are two broad areas to consider: US Route 395 and the areas it provides access to on the east side of the Sierra; and the trans-Sierra passes and highways.

US Route 395 and the Eastern Sierra

US Route 395 is a major north-south route through all three Pacific Coast states (and passes briefly through parts of Nevada east of Lake Tahoe), running from the Canadian border to the Los Angeles area. For Sierra Nevada visitors it is the major route up and down the east side of the range. If you are going to look for aspen color in the high country (and low-country color later in the season) you are virtually certain to make use of US 395.

It is a spectacular route, often running through high-desert terrain with the steep eastern escarpment of the

Sierra rising many thousands of feet above to the west. In places it climbs to well over 8,000 feet of elevation, but in the far southern reaches of the Sierra it drops to hot and dry desert country. For fall color fans it provides not only access to side roads leading to the high-country aspens, but beautiful trees right along the highway. Later in the season, Owens Valley cottonwood trees provide another source of color.

Let's take a quick trip south from the junction of US 395 and California State Route 89 at the base of Monitor Pass to the Bishop area, focusing primarily on aspen color and looking at both the main route and some of the nearby areas to which it provides access.

From the SR 89 junction near Topaz Lake, US 395 heads south through the Antelope Valley past Coleville, where big cottonwood trees provide autumn color later in the season. Past Walker, US 395 climbs to the junction with California State Route 108, where a right turn leads to aspens along the approach to Sonora Pass.

Back on US 395, the road curves abruptly east and climbs—keep an eye out to the south and west and you may spot aspen color on nearby slopes and valleys. If you have the inclination and are equipped for some rough driving, watch for gravel side roads that can take you to

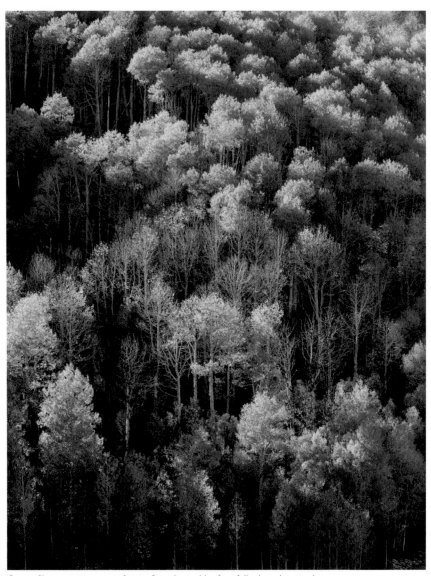

Eastern Sierra aspen trees near Conway Summit transition from full color to bare trunks.

some of these aspen groves. (Exercise caution, since the quality of these roads ranges from decent to "you probably don't want to go there.")

As you continue on US 395, keep your eyes open and you will see occasional lovely trees as you travel toward Bridgeport. The broad valley before the town offers distant views across pastures toward the Sierra, and you might see distant aspen color or closer cottonwood color. Bridgeport offers the opportunity to buy some of the most expensive gas in California.

The road turns south again at Bridgeport, and there is a good chance that you'll be able to spot aspen color in the distance along the eastern base of the Sierra. As was the case when we passed the Sonora Pass turnoff, there are quite a few possibilities for those who want adventure

Autumn color in an Eastern Sierra meadow near Sonora Pass

off the main highway. These range from well-used routes to popular east-side locations to poorly maintained gravel roads whose destinations may be unclear. Many of the westbound roads climb to popular lakes, and one of the first departs near here for Twin Lakes.

Soon US 395 passes the eastward turnoff to Bodie State Historical Park, site of a historic mining town which has become famous as a ghost town. There is some fall color along that route, and you may find a different sort of aspen scene: small clusters of colorful trees set against the spare and monochromatic high-desert landscape.

From here, US 395 ascends to 8,143-foot Conway Summit, the highest point on the road before it drops to Mono Lake, and the location of one of the largest displays of aspen color in the Eastern Sierra. Find a safe place to pull over and view the overlapping groves that start below the roadway and ascend toward the peaks. Arrive on the ideal day and you'll find brilliant colors from gold to orange to green spread in front of you, and if you are especially lucky you might find them backed by new autumn snow. The best time to photograph here is in the late afternoon, when the trees are backlit.

Sparse, colorful aspen trees in the high sagebrush country east of the Sierra Nevada

Side Trip: Virginia Lakes Road

The side road to Virginia Lakes leaves US 395 and heads to the west from Conway Summit. A short distance up this route there are areas of thick aspen growth with decently large trees. The tall mountains surrounding the area at the end of this road impart a strong alpine feeling, and if you are so inclined you can follow a trail up higher. If you and your vehicle are ready for some back-road driving,

you can find more aspens along rough, gravel Dunderberg Meadow Road. It begins in evergreen forest and travels north along the upper reaches of the aspen-covered slopes that you might have admired from the Conway Summit area. Eventually this rough route descends through aspen groves, crosses open country, and heads back toward US 395 north of Conway Summit.

US 395 to Mono Basin

Back at the Conway Summit junction of US 395 and Virginia Lakes Road, our main route continues south, immediately beginning the descent toward Mono Basin. There are many patches of aspen trees along the upper section of the descent, though it can be difficult to find a place to pull over and view them. There is a scenic overlook, a spectacular spot with beautiful views across Mono Basin and down the Sierra escarpment, from which you may spot a few aspens as well. From here the road descends rapidly, heading south to Mono Lake. Between here and the town of Lee Vining there are a number of aspen-viewing possibilities. These include small but colorful groves right along the roadway, and along the side road up into Lundy Canyon.

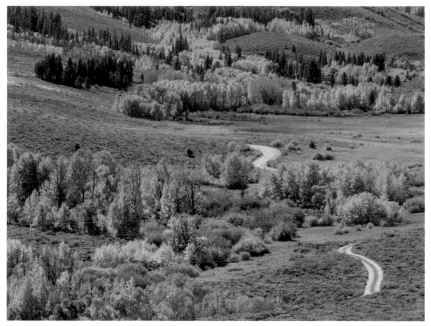

A country road winds among groves of Eastern Sierra Nevada autumn aspen trees.

Side Trip: Lundy Canyon

Lundy Canyon is a special treat when aspen color is at its peak. You are rarely far from aspens along this road, and you'll be able to spot them along the stream, above Lundy Lake, in campground areas, and on the slopes high above the canyon. After the rustic resort at the upper end of Lundy Lake, the road becomes a very narrow gravel track that skirts beaver ponds and then climbs to an end, where

there are more aspens in the mixed forest. Hikers can take off from here and climb even higher into this lovely U-shaped alpine canyon.

US 395 to Lee Vining

Continuing south, US 395 arrives at the town of Lee Vining. Situated above the western shore of gigantic Mono Lake, this is the eastern gateway to Yosemite National Park. The town can be a very busy place during the high season, but it has an almost isolated feeling when State Route 120 over Tioga Pass closes for the season. Just outside of town at the junction with SR 120, you'll find the (self-declared) "world-famous" Whoa Nellie Deli. In addition to food, during aspen season you are likely to find a lot of fellow aspen aficionados and photographers here.

Side Trip: Lee Vining Canyon

SR 120 climbs into the abundant aspens of Lee Vining Canyon. The sheltered lower canyon can be a good place to look for color later in the season, after some of the higher aspens have passed their prime. Many aspens are found along Poole Power Plant Road, which leaves SR 120 just before it begins to climb steeply. Gravel roads provide access to several Forest Service campgrounds (one of

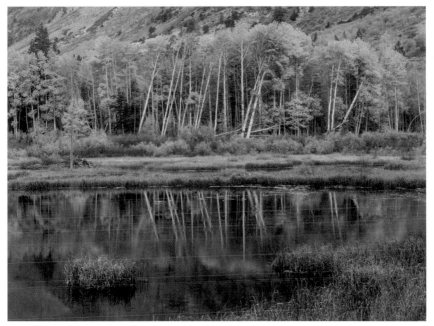

A colorful grove of aspens reflected in an Eastern Sierra Nevada pond

which is aptly named Aspen Campground) and the power plant located at the end of the road. Many of the trees in this valley are quite large and produce beautiful color. If there is a downside it is that it can be hard to find open, long views, though more intimate scenes are abundant, especially along Lee Vining Creek.

Back on SR 120, the road follows an impressive route up the side of this alpine canyon, crossing immense rocky

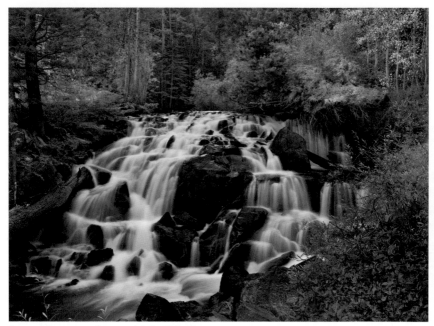

Autumn foliage surrounds a cascade in Lee Vining Canyon

slopes as it climbs steadily. Eventually the road loops back to the left, passing some small, high-elevation aspens before crossing the head of the canyon to reach Ellery Lake. Here the climb pauses briefly before reaching the gravel side road to Saddlebag Lake and then resumes on the way to Tioga Pass and the entrance station for Yosemite National Park.

US 395 to June Lake

US 395 continues south from the Lee Vining area and soon enters open terrain with expansive views in all directions: east toward the volcanic Mono Craters, west toward the high Sierra Crest of the eastern boundary of Yosemite National Park, and south toward the mountains above the resort town of June Lake.

Side Trip: June Lake

State Route 158, better known as the June Lake Loop, leaves US 395 just before the junction with eastbound SR 120 (which provides additional access to Mono Lake and points beyond) and heads south. The June Lake Loop is prime aspen country, and when it is at its peak, it wouldn't be hard at all to devote an entire day to this area.

Although it is easy to find color all along this driving loop, it is worth noting a few highlights. An area known as Parker Bench is full of colorful trees and other vegetation in the fall, and a good gravel road leads to the trailhead for hikers heading to Parker Lake, just below the huge canyon below Parker Pass. Impressive long views from areas around Grant Lake extend all the way back to peaks at the head of the valley. (Grant Lake is a man-made reservoir, so

it can be less attractive if the water level has been lowered late in the season.) Along the drainage of Rush Creek and past Silver Lake there are many more aspens along the roadway, and distant trees are visible on the higher slopes. Aspens continue as the route loops toward June Lake and the June Mountain ski area, although vacation cabins, businesses, and other signs of civilization become more abundant. After passing the ski area, Gull Lake, the town of June Lake, and large June Lake itself the route loops back to meet US 395 again.

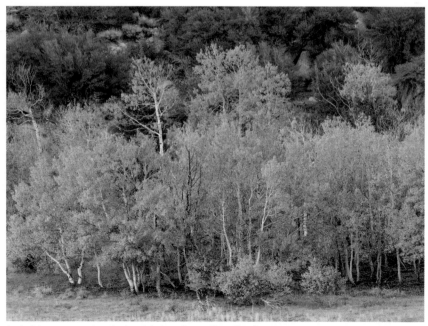

A colorful aspen grove along the June Lake Loop, Eastern Sierra Nevada

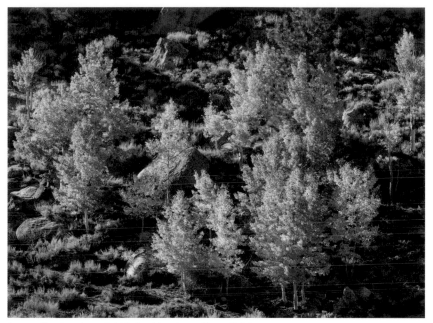

Aspens with autumn leaves in high-desert terrain near Mammoth Lakes

US 395 to Mammoth Lakes

Before long US 395 arrives at the junction with State Route 203, which climbs west to the resort town of Mammoth Lakes, the Mammoth Mountain ski area, and over Minaret Summit (at the Sierra Crest) before descending into the San Joaquin River drainage and Devils Postpile National Monument. There are aspens here, too. You can spot some near the turnoff from US 395, and there are fine examples of color in other spots, including the Devils Postpile area

and along the Mammoth Scenic Loop back road between the Mammoth Lakes area and US 395. Even though the main aspen attractions lie elsewhere, Mammoth Lakes may be of interest as a place to eat or stay overnight during your aspen quest.

As US 395 continues to the south the Long Valley Caldera becomes more apparent, especially in the large valley to the east of the highway. Remnants of the caldera's ancient volcanic past can be found in the form of numerous hot springs.

Side Trips: Convict Lake and McGee Canyon

The turnoff to Convict Lake is a few miles south of the Mammoth Lakes area. After a short climb to the west on Convict Lake Road you will find yourself in the lake's valley. The road follows the creek draining the lake, and lower-elevation aspens along its length often produce good color. At the lower end of the lake you'll find a resort, a campground, and day-use areas. The view of Convict Lake from its east shore is iconic, and you may recognize one of the most popular viewpoints near the outlet stream. The road dead-ends partway around the south side of the lake, and there can be colorful trees in this area, too. The longer views across the lake include distant aspens and towering peaks.

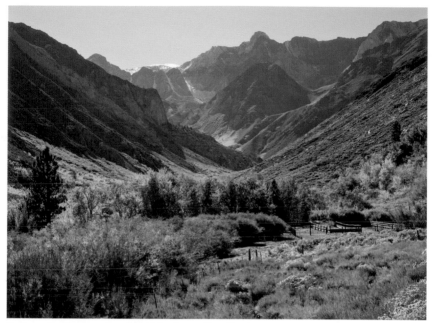

Stock corral in afternoon autumn light, McGee Canyon, Sierra Nevada

Back on US 395, the road into McGee Canyon along the McGee Creek drainage comes up quickly. It climbs steeply toward the mountains, then briefly loops back around toward the valley, and changes to gravel before the McGee Pack Station. In places the route passes along the aspen-lined creek, and the road ends at a parking area for the McGee Canyon trail, where the stream runs through a nice grove of aspens. The trail from here is popular and not difficult, and it can take you to more aspens farther up the canyon.

33

Side Trip: Rock Creek Road

There are many aspens along US 395 as it passes Lake Crowley and begins to climb toward Tom's Place and then Sherwin Pass, passing lovely meadows and occasional aspens along the way.

At Tom's Place, Rock Creek Road provides another route into the higher mountains. This beautiful side road soon passes aspens ranging in size from small to quite large along the creek. Rock Creek Road traverses a large range

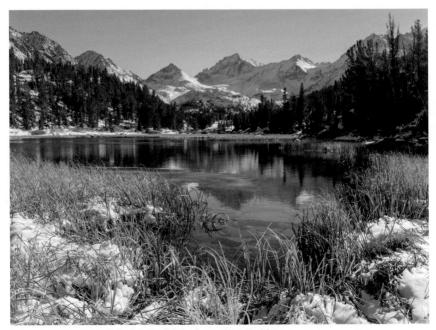

Early-season autumn snow below Bear Creek Spire, Eastern Sierra Nevada

of elevations, so there can be colorful trees from early to much later in the aspen season along its length. Eventually the road narrows after passing Rock Creek Lake, but the aspen show continues, along with spectacular landscape views, as the route approaches Mosquito Flat and ends at a parking loop. There is a trailhead, and a short uphill hike brings you to an open valley with views toward the towering Bear Creek Spire.

US 395 to Bishop

After crossing Sherwin Summit US 395 begins a long descent toward the town of Bishop. Aspens are sparse along the main highway here, but more can be found along the Lower Rock Creek Road/Sherwin Grade area to the west. As US 395 descends, the view to the south toward Round Valley, Owens Valley, the Bishop Creek drainage, Mount Tom, and the peaks of the Sierra Crest is stupendous, and you may want to pull over partway down to take a good long look.

At the bottom of the descent, US 395 passes between barren hills to the east and relatively lush Round Valley to the west. Old cottonwood trees, some of which are very large, are scattered across Round Valley. After the aspens change color up above, these cottonwoods continue to

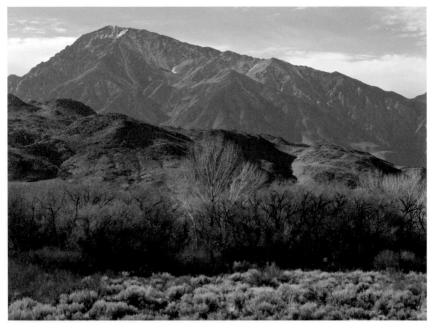

Massive Mount Tom rises above the Tungsten Hills and the high-desert terrain of Owens Valley near Bishop.

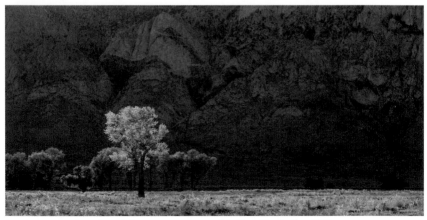

Autumn cottonwood trees beneath the eastern escarpment of the Sierra Nevada, Round Valley

produce a beautiful color show, especially late in the day when they are backlit by low-angle sunlight coming across the Sierra. Several roads cross this valley; Pine Creek Road heads off toward the old mining hamlet of Rovana and ends several miles farther on.

Bishop is a good-sized town by Eastern Sierra standards, and there are plenty of restaurants, motels, gas stations, and shops. It is also the access point for visiting Bishop Creek, one of the foremost locations for aspen color in the state.

Side Trip: Bishop Creek Drainage

State Route 168 (also known as West Line Road) leaves US 395 in the downtown Bishop area and heads out, soon ascending in a mostly southwest direction into the dry Eastern Sierra landscape, with excellent views of the peaks towering above. Before long it passes through boulder-strewn Buttermilk Country and quickly climbs southwest up the canyon of Bishop Creek. The first aspens of the climb appear here, and trees along the creek can provide reliable color later in the season.

The three primary destinations in this drainage are North Lake, Sabrina Lake, and South Lake. At the first major junction along SR 168 you can turn left and head up South Lake Road toward South Lake. The aspens that you

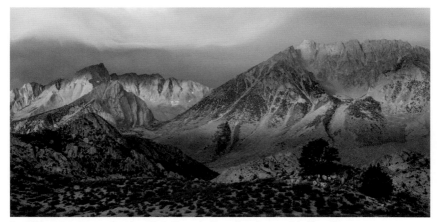

Dawn light on a stormy morning above Basin Mountain, Mount Humphreys, and the Sierra Crest

first encountered in the lower canyon continue along the lower part of this road as it passes a couple of campgrounds and a small village. A straight section of the route passes very large aspen groves which rise up the slopes, and which produce an intense color display at their peak. Along this road there are many places to pull over and enjoy the show, including a few gravel side roads and trails. After passing through an especially pretty area with a meadow, the road ascends steeply toward Parchers Resort, beyond which it narrows and then ends at South Lake.

Retracing this route back to the junction with SR 168, you can rejoin the main road as it continues up the canyon and passes through Aspendell. This village sits in a large grove of aspen trees that extends up the valley beyond the

Cardinal Resort. Great views of aspens and peaks farther up the valley begin at Aspendell.

The junction with the narrow and mostly gravel North Lake Road is above Aspendell. The beginning of this road is not difficult, but later on it climbs and twists and hugs a steep hillside along the edge of an impressive drop-off. The route passes lots of aspens, and you'll probably want to pull over and wander around a bit. Soon the road passes the exposed drop-off, ascends a short steep section, and arrives at a small parking area for visitors who want to

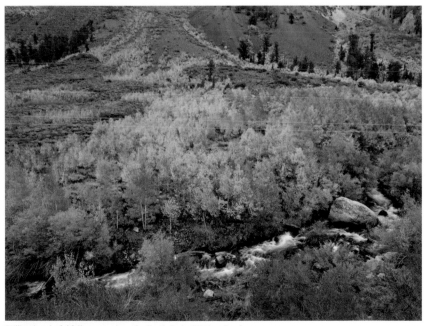

Brilliantly colorful fall aspens along the South Fork of Bishop Creek

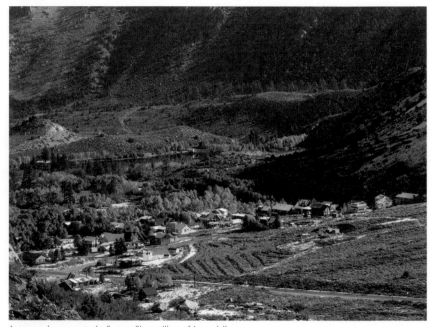

Autumn colors come to the Eastern Sierra village of Aspendell.

walk to North Lake. The classic view from North Lake features lots of aspens and the towering Piute Crags. There are aspens all around the lake, including some groves that almost cover the road. You can continue to a campground and a backcountry trailhead, or circle to the far side of the lake, where there are more aspen groves.

After you drive back down North Lake Road, a right turn onto SR 168 takes you up the canyon toward Lake Sabrina. As you get closer to the lake, in many places the

landscape becomes more intimate and you have good, close looks at aspen groves. Lake Sabrina, like South Lake, is a water storage facility with a dam across the valley at its outlet. A pond just below the dam is a popular stopping place. While the canyon and mountains above the lake are impressive, the water level of this lake may be quite low late in the season.

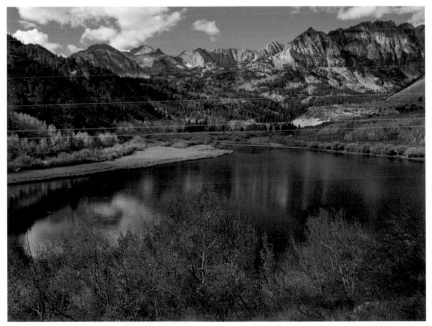

Colorful autumn aspens surround the shores of North Lake, with the Sierra Crest beyond.

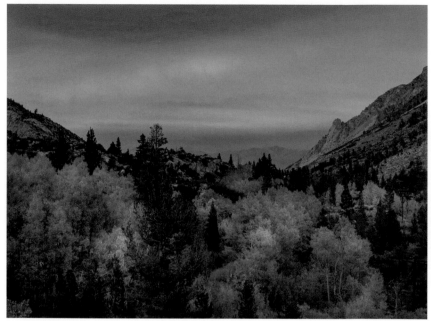

An autumn sunset high in Sabrina Basin in the Eastern Sierra Nevada

Beyond Bishop Creek

In many ways, the Bishop Creek area might be the premier aspen location in the Sierra—which is not at all to say that others aren't similarly beautiful. In fact, there are aspens along almost every high creek and valley on the east side of the range. You can start with the hot spots described here, but when you become passionate about these beautiful trees and their annual fall transformation, you

will be ready to move beyond the tried and true to strike out on your own, imagining where other aspens might be found, picking up occasional clues from friends or from photographs, coming back to groves you discovered on summer hikes and pack trips, and more. While some of the best-known spots are truly impressive, seeking out the more obscure but equally beautiful views can be even more rewarding—a lifelong adventure.

Passes and Trans-Sierra Routes

Highways over several trans-Sierra passes and other high areas between Tahoe and Yosemite provide good opportunities for aspen viewing. In fact, it wouldn't be a bad idea to simply head over *any* of these passes in early October looking for color. Keep in mind also that these main routes are not the whole show. While you can simply drive along them and find beautiful color, they also take you to a plethora of side roads worth investigating.

California State Route 88: This highway heads east from the Stockton area and crosses the Sierra Crest at Carson Pass before descending into Hope Valley, where there is a junction with SR 89 and a left turn climbs north over Luther Pass and descends to Lake Tahoe. SR 88 offers plenty of opportunities for aspen viewing, beginning

on the west side near Silver Lake. Here you will begin to encounter isolated trees and stands which contrast with the backdrop of darker conifer forest as you ascend toward the east. There are extensive stands of aspens between Caples Lake and Carson Pass, with small trees creating a more intimate aspen experience. The pass itself is not among the most remarkable viewpoints on the crest, though the views open up considerably after you drive through the gap at the pass and head east, dropping into Hope Valley. Here there is extensive aspen color close to

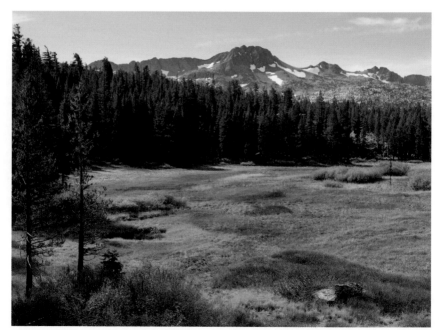

Autumn comes to a large meadow just below the Sierra Crest near Carson Pass.

the road and out along the floor and the slopes of the valley. In fact, there are aspens throughout this valley, and noteworthy groves are found just past the SR 89 junction, near Sorensen's Resort. More trees are visible along the road as it descends to the east toward Woodfords.

California State Route 4: This might be one of the most varied routes in northern California, starting within sight of San Francisco Bay, ascending to subalpine Ebbetts Pass, and then descending toward the hamlet of Markleeville. The route begins in the town of Hercules and heads east through Delta country and across the Central Valley by way of Stockton before ascending the Sierra foothills toward Sonora—an area to visit later in the season for foothill fall colors. The highway works its way upwards toward the ski resort at Bear Valley, where the scenery becomes more alpine and some aspens are found. The road narrows beyond Alpine Lake as you leave the all-season portion of the route behind. Although there are interesting vistas along the way, Ebbetts Pass itself is less spectacularly alpine than some of the other passes. There are scattered examples of autumn color along this route, including aspens and cottonwoods and more, some along the bottom of the river canyon and others high above on canyon walls.

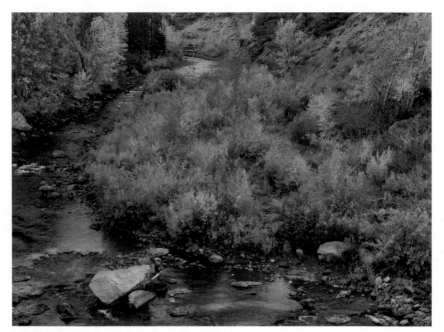

Fall colors along the canyon of the East Carson River in California

California State Route 108: Highway 108 begins in the Central Valley at Modesto and joins SR 120 from Oakdale to near Sonora in the foothills. The route starts to feel like a real mountain highway by the time you reach the area around Strawberry and Pinecrest. Eventually it bends slightly to the southeast, narrows, and ascends an increasingly steep and twisty road toward Sonora Pass. This is the highest pass north of Yosemite, and its upper

reaches have an alpine feeling, with steep canyon walls and views of rugged peaks. You'll find plenty of aspens here, though often mixed in with other trees. Once over the pass, the road descends (very steeply in places). There are a lot of aspen trees along this section of the road and the relatively flatter section before the junction with US 395.

California State Route 120: For good reason, SR 120 may be the best-known trans-Sierra route south of Lake Tahoe. After leaving US 99 in the Central Valley and

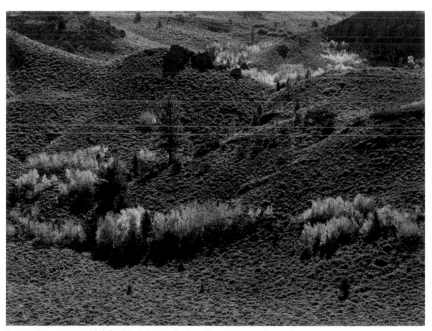
Scattered aspen trees with fall colors in barren Eastern Sierra hills near Sonora Pass

entering the Sierra foothills, it branches off from SR 108 and heads toward Yosemite National Park, to which it is the main route from the San Francisco Bay Area. A few miles inside the park boundary it branches east (where it is known as Tioga Pass Road) and heads across the park's beautiful high country, passing Tenaya Lake and traversing Tuolumne Meadows before climbing to the Sierra Crest. After crossing Tioga Pass—the highest major trans-Sierra pass at just under 10,000 feet elevation, and the last pass

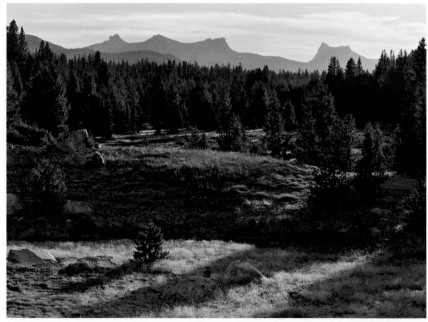

Golden late-season evening light on a small meadow along the Dana Fork of the Tuolumne River, with the Cathedral Range in the distance

before the vast stretch of wilderness to the south—the road descends through spectacular Lee Vining Canyon to the junction with US 395. Although there are some aspens along the roadway in the park—along with some subtler fall color from golden-brown ferns, willows, and other smaller plants—the real aspen color starts east of the pass. The extensive groves in Lee Vining Canyon often change color a little later than some of the higher groves.

US Routes 50 and 80: Major routes such as US 50 and US 80 are perhaps not quite as friendly to explorers poking around the Sierra looking for fall color, though you can find color along their corridors, and they are good routes to and from fall color areas in the Lake Tahoe region. It is also useful to keep them in mind should you find yourself on the east side of the mountains when a surprise storm drops enough snow to close the other passes: these all-year highways might be your most reliable routes back over the Sierra.

California State Route 89: Highway 89 is a north-south route, rather than a trans-Sierra pass, that covers a great portion of the Northern Sierra and continues north to near Mount Shasta. The far northern sections are beyond our scope here, but the section through and south of the Lake Tahoe region has a lot to offer, with three areas of particular merit.

Heading south from its junction with US 80 at Truckee, the road goes to the north end of Lake Tahoe and then follows the western shoreline of the lake. Tahoe is a busy, crowded place, but there are aspens here—for example, in the southwest portion around Fallen Leaf Lake.

Heading south from Tahoe, SR 89 climbs over low Luther Pass, with nice aspen groves near the summit, and drops into Hope Valley, an area of extensive and beautiful fall aspen color. (There is more information about Lake Tahoe and Hope Valley later in this chapter.) Here the road briefly joins with SR 88 along the descent to Woodfords before again branching, this time toward Markleeville.

A few miles past Markleeville, SR 89 reaches a junction with SR 4 (which heads southwest over Ebbetts Pass), turns left, and climbs up and over Monitor Pass. The Monitor Pass section of SR 89 provides spectacular panoramic vistas and there are many aspens, including very large groves on both sides of the pass itself. Trees are exposed to light from both the east and west, making this a good place for photography both morning and evening. The route ends at its junction with US 395, just south of Topaz Lake.

These trans-Sierra routes are not the only ways into the higher reaches of the mountains; other roads penetrate the

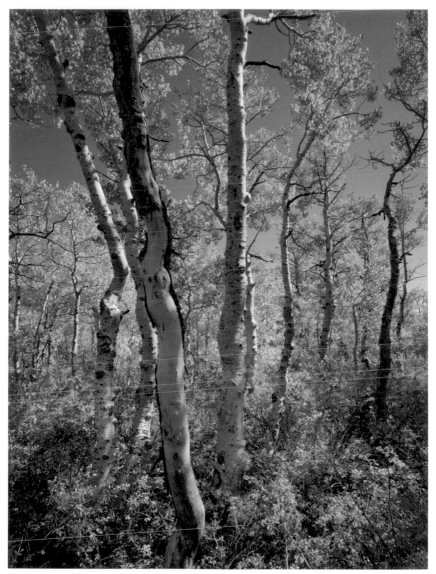

Aspen groves near the summit of Monitor Pass

range from both sides without crossing it. For example, several routes enter the range from the west in the Kings Canyon Sequoia National Park area. The ends of roads into the San Joaquin River drainage from the east and west are separated by only a few miles.

LAKE TAHOE AND HOPE VALLEY

The greater Lake Tahoe region offers wonderful autumn color, especially during the first few weeks of October. There is a lot of color right around the lake itself, and many other locations with fall color are only a short drive away, making Tahoe a fine starting place for exploring other areas.

Technically, the Lake Tahoe Basin is not "in" the Sierra Nevada, since it lies between the Sierra Crest along the west side of the lake and the Carson Range to the east, and because its waters drain to the east via the Truckee River. Yet, in the same way that we associate other east-of-the-crest areas (such as Mono Lake and Mammoth Lakes) with this range, a trip to Tahoe feels like "going to the Sierra."

The Lake Tahoe region is almost unique among these mountain areas in its mixture of quite urban areas and bustling attractions close to natural and wilderness areas. (Mammoth Lakes has some of the same flavor.) Casinos and wilderness are sometimes only a short drive apart,

and a great deal of the color here is found near homes, cabins, and resort facilities.

Since the elevation of the lake is just a little more than 6,200 feet, fall color can arrive slightly later than in some higher locations, although some trees at the lake level may change earlier. The elevation also affects the mixture of trees: you can find aspens, cottonwoods, and even non-native color in some of the urbanized areas.

One popular way to experience the variety of Lake Tahoe is to circumnavigate its seventy-two-mile perimeter.

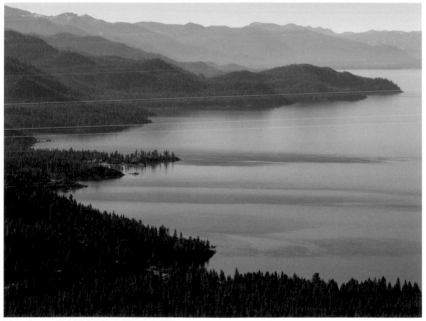

Blue water and light above Crystal Bay, Lake Tahoe

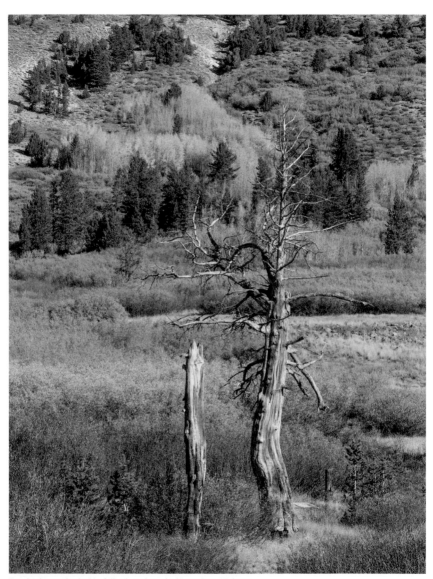

Two dead snags backed by fall colors along the Mount Rose Highway

When deciding where to start and which direction to travel, consider how the light will affect photography in different areas of the lake. In the early morning, you are more likely to find direct light on the west side; on the east side, the light will be softer and more shaded. Later in the day you are more likely to find direct light on the east side of the lake and more subtle light on the west side. You might plan to be in photogenic areas early and late in the day and reserve the midday hours for a hike or a meal stop. Though a plan isn't strictly necessary, here's one suggestion:

Begin at Stateline, Nevada, and head north on US 50, where colorful trees are scattered here and there all along the route up the east side of the lake. Eventually you leave the shoreline near Glenbrook where US 50 climbs to the east. The route around the lake turns left onto Nevada State Route 28, but if you drive toward the summit of US 50 first you will find impressive stands of aspen a ways up the main road. Returning to the junction with SR 28 and heading north, the route passes some large aspen groves. Spooner Lake, in the Lake Tahoe Nevada State Park, is a great place to stop and find fall color.

SR 28 eventually returns to the shoreline as it approaches Crystal Bay and Incline Village. This is a spectacular

section of the road, with beautiful views of the shoreline and the lake, though opportunities to pull over and stop are limited. The route swings to the west as it begins to follow the northern shoreline, and just after Incline Village it intersects with the Mount Rose Highway (Nevada State Route 431), which ascends to the right toward the Mount Rose ski area. This side route is worth the drive, both for expansive views of the north end of Lake Tahoe and for groves of aspen trees near the Mount Rose ski area and in the upper sections of the road as it begins its descent toward Reno.

Back at its junction with the Mount Rose Highway, SR 28 continues around the lake through a fairly developed area, and this will be the case until well after the route turns south just beyond Tahoe Vista. There are a number of tourist-oriented areas, with motels and restaurants, and you will also pass many residential areas. There is fall color here, but it is often seen against an urbanized setting. However, there are places where the public has access to the northern shoreline of the lake, and the juxtaposition of yellow foliage (often from cottonwood trees) and the blue water and distant mountains can be striking.

After Tahoe City the route turns south on West Lake Boulevard (SR 89) along the west shore of the lake.

Colorful autumn leaves along the northern shore of Lake Tahoe

This area is also quite developed, but the presence of mountains to the immediate west and thicker forest cover begins to mute the strongly urbanized feeling of sections of the north shore. The road here alternates between passing right along the shoreline and traveling just a bit farther inland. In the shoreline sections there are often big and colorful cottonwood trees, and other trees provide scattered color in between.

As SR 89 reaches the Meeks Bay area it becomes Emerald Bay Road and rises away from the lake before it reaches D. L. Bliss State Park and then Emerald Bay. While Emerald Bay is not necessarily a fall color area, it is probably worth a stop for its iconic views. After the route crosses the stream that drops into Emerald Bay—and trailheads to wilder areas above—it quickly ascends past an overlook and then traverses the top of a narrow and spectacular ridge before beginning a steep descent toward

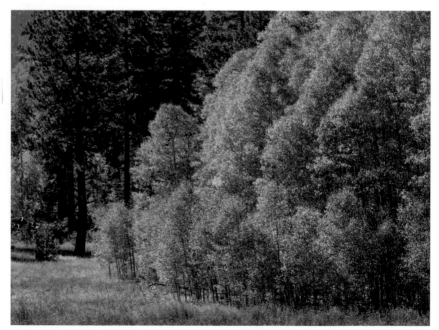

A grove of colorful aspens along the road to Fallen Leaf Lake, in the Lake Tahoe area

the southwest corner of the lake. At the bottom of this descent there are some large aspen groves, and if you want to see even more you can take the short, narrow side road up toward Fallen Leaf Lake. This route passes some large groves of aspens in the lower, flat section, and there are scattered trees as it reaches Fallen Leaf Lake.

Beyond this turnoff the route quickly becomes urbanized once again as it heads toward the community of South Lake Tahoe, from which you can complete the loop back to Stateline.

Hope Valley: No consideration of Tahoe-area fall color is complete without including beautiful Hope Valley, one of the most spectacular aspen locations in this part of the Sierra. It is a short drive south of the Lake Tahoe Basin, just a few miles away from the lake via SR 89 over Luther Pass. The valley descends roughly from the east side of Carson Pass along SR 88 to the area near the junction of State Routes 88 and 89 (Luther Pass Road).

If you are looking for aspen color in this part of the Sierra, you will want to visit this area. It is mostly a broad and relatively flat valley, lined with higher ridges and filled with alternating conifer forest, aspen forest, and open meadow areas. Creeks here flow into the West Fork of the Carson River.

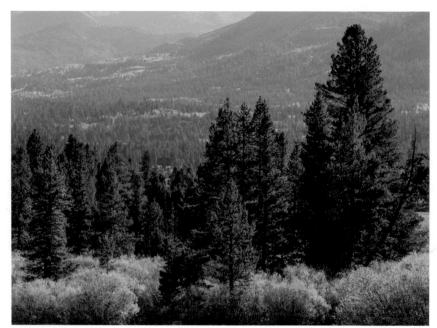

Autumn forest, including willow and aspen, stretches up Hope Valley toward Carson Pass

Heading for Hope Valley from Tahoe, the first indications of aspen color come as you approach the summit of Luther Pass and begin to see aspens among the conifers. There are many aspens along this section of the road on either side of the long, flat meadow at the pass. Many more are visible as the route descends into Hope Valley—alongside SR 89, down in Hope Valley itself, and on the hillsides above the valley.

One of the most notable areas is just east of the SR 88/89 intersection at Picketts Junction and near Sorensen's Resort, where big groves line the highway and there is room to carefully pull over and view them up close. However, the drive up SR 88 back to the west toward Carson Pass offers more and more colorful groves. Some are away from the road and across the large meadows along the creek down the center of the valley, but farther up the road, they line the main highway and in some places they ascend far up

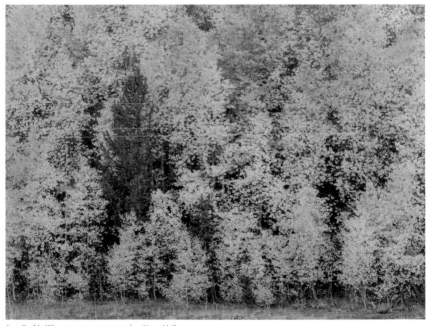

A wall of brilliant autumn aspen color, Hope Valley

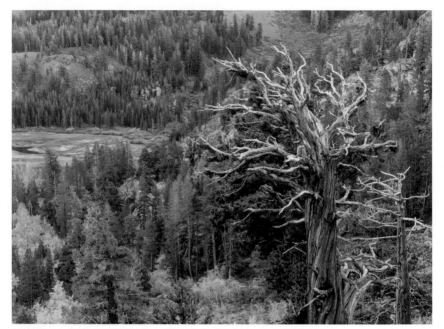

An old tree stands above an Eastern Sierra Nevada valley full of autumn aspen color.

the surrounding slopes. The color show continues all the way to the start of the final steep ascent to Carson Pass through rocky and barren areas—though even here there are beautiful views back down into the valley that include some of the larger colorful groves.

Once you are in Hope Valley, you might want to further explore the area. Blue Lake Road leaves SR 88 and heads south toward a group of lakes. SR 88 continues on over

Carson Pass toward the Kirkwood ski area, and there are big groves of aspens along the road as it descends west of the pass toward Kirkwood. If you have the appropriate vehicle and driving skills, there are also some interesting gravel roads that head off in various locations east of the pass. The aspens continue below Picketts Junction, too, and you can see more of them if you continue down the canyon toward Woodfords.

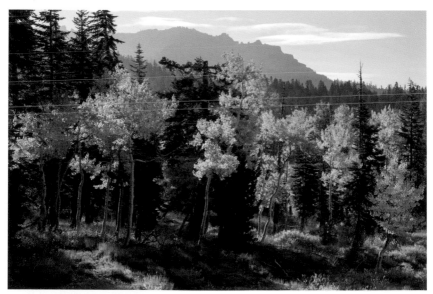

Aspens along SR 88 as it approaches Carson Pass from the west

ASPENS AND SNOW

On an ideal Sierra autumn day, the sun shines and the temperatures are comfortable and even warm. However, this is a transitional season in the Sierra, and conditions can go from summerlike to wintery in less than a day.

Early storms bring snow along with bone-chilling temperatures and strong winds. Driving becomes more challenging, snow chains may be required, and some areas may become inaccessible. But if you are prepared for the weather and are willing to adapt your plans, the combination of fall color and snow can be irresistible.

When the distant views fade behind the scrim of falling snow and mist, you become more aware of small and close details—the patterns of frost on autumn leaves, the texture of rock, the sound of snow crunching under boots, the tickle of snowflakes on your face, the tracks of small animals.

Storms don't usually last long in autumn, and they rarely drop more than a few inches of snow—unlike the winter storms, which can go on for days and bury everything in feet of snow. In autumn, sometimes you can watch the snow arrive, fall, and clear in the span of a single morning.

If you do encounter one of these early storms during your fall color visit to the Sierra, count yourself lucky. As beautiful as a sunny fall day with bright colors is, when it snows you have a chance to experience a very special side of the autumn experience.

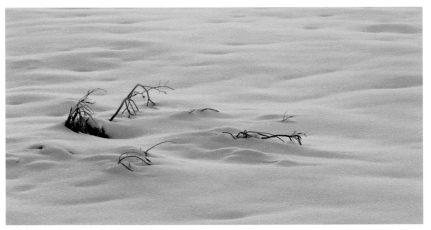

Early fall snow buries meadow plants in the Eastern Sierra.

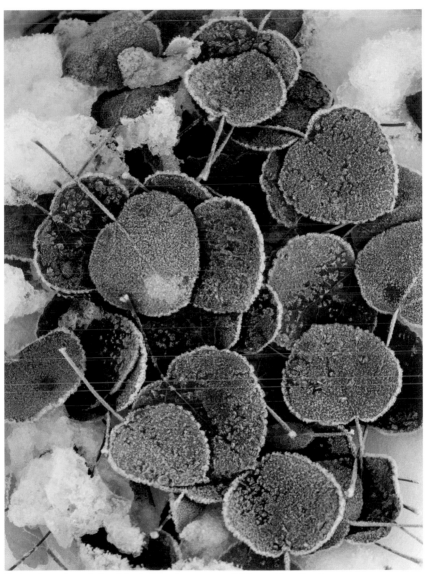

Blackened aspen leaves in frost following an early autumn snowfall, Eastern Sierra Nevada

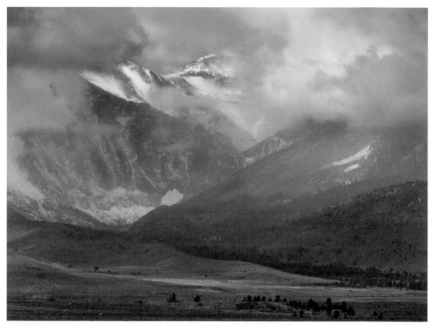

An October storm brings snow to the Parker Canyon area of the Eastern Sierra.

An autumn snowstorm obscures aspen trees beyond a creek flowing through Hope Valley.

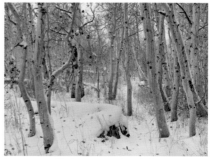

Autumn snow blankets a grove of nearly bare aspen trees.

An early-season storm brings snow to the extensive aspen groves of Conway Summit.

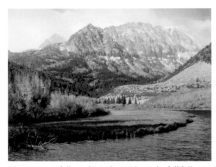

Autumn snow falls on Piute Crags above the fall foliage at North Lake.

The first snow of autumn falls on an Eastern Sierra beaver pond.

FALL COLOR IN YOSEMITE VALLEY

Yosemite Valley provides a special fall color experience that is different from what you see at higher elevations, such as Yosemite's high country, where wonderful fall color is visible along Tioga Pass Road/SR 120 (see "Passes and Trans-Sierra Routes" in this chapter), and the east side of the Sierra.

The Valley is renowned for its stunning and unparalleled natural features...and for the hordes of visitors drawn to this famous place. The main tourism season begins to wind down in September after the Labor Day weekend, and by October the Valley is no longer quite the crowded, urbanized, noisy zoo that it can be on the busiest days of summer. The wild waterfall show of late spring and early summer is over, and the iconic Yosemite Falls may be completely dry.

Fall colors arrive in Yosemite Valley later than in the high country, with the peak typically near the very end of October and beginning of November. (Think Halloween!) The meadows will have turned golden-brown already. The valley's characteristic oak trees tend more toward brown than the brilliant yellows of other fall foliage, but in the right light they are very impressive, especially in areas

The face of El Capitan is reflected in the surface of a pool full of autumn leaves along the Merced River.

where trails pass beneath the canopies of large trees. The autumn color of dogwood trees is subtle, a muted range of red to yellow. The bigleaf maple trees may be the most spectacular producers of colorful fall foliage, as their gigantic leaves turn intensely yellow. The cottonwood trees, many of which are found along the banks of the Merced River, also produce brilliant yellow leaves and their open pattern of growth yields luminous effects.

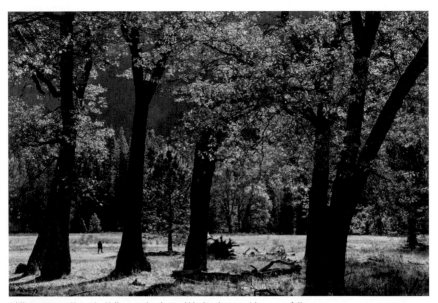

A hiker crosses a Yosemite Valley meadow beyond black oak trees with autumn foliage.

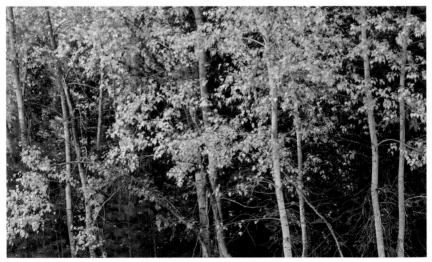

Cottonwood trees with golden autumn leaves along the bank of the Merced River

A Note about Light

Pay careful attention to the light in Yosemite Valley. Because the Valley is oriented roughly east-west and is relatively narrow and deep, the light changes as the day progresses, and various areas receive light or fall into shadow. Because the south side of the Valley gets less sun as fall progresses toward winter, there are lots of opportunities to photograph foliage in soft, shaded light.

One strategy for photographing colorful foliage on the Valley floor is to follow the edge of the light as it moves across the landscape. Placing a well-lit subject in front of

A very cold autumn morning brings a touch of frost to late-fall oak leaves in Yosemite Valley.

a darker background can produce a dramatic effect. If you find the right subject at the right time you can combine your backlit subject with a shaded background.

Taking a different approach, you can also look for areas that remain in shadow, where the light can have a soft quality that makes colors glow. Head for areas along the south side, where tall cliffs produce shade later in the day, but be aware that the light in such locations can have a blue quality. (For more tips about photographing autumn foliage, see the next chapter, "How to Photograph Fall Color.)

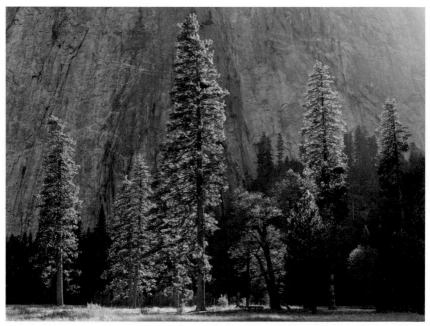

The immense granite face of Cathedral Rocks looms behind trees of El Capitan Meadow in afternoon light.

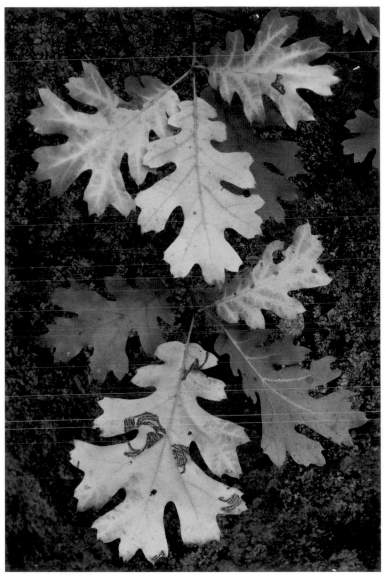

Colorful autumn oak leaves on shaded granite

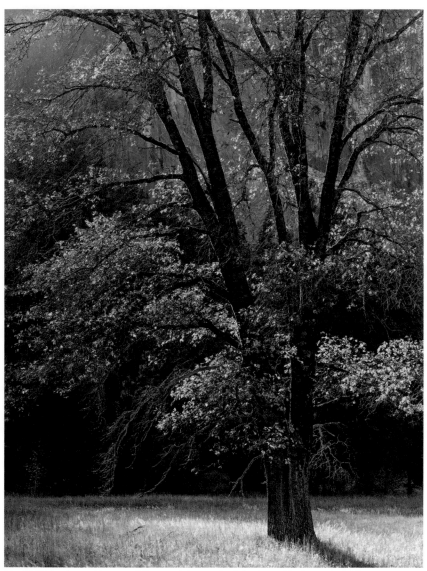

A backlit black oak tree with autumn foliage stands in a meadow below Sentinel Rocks, Yosemite Valley.

Yosemite Valley Fall Subjects

Any visitor to Yosemite Valley will agree that there is no shortage of potential photographic subjects! What follows is by no means comprehensive, but it may help get you started if you are looking for fall photographic opportunities.

Oak trees: While first-time visitors are justifiably captivated by the spectacular waterfalls and the towering granite cliffs, for those who spend more time in the Valley the ubiquitous black oak trees eventually become a big part of the identity of the place. They are found throughout the Valley, generally in and around the many open meadow areas, such as Cook's Meadow in the Yosemite Falls area and El Capitan Meadow farther west. In the fall their changing leaves can glow beautifully when lit from behind, and their color often contrasts nicely with the darker shapes of their trunks and branches.

Given how the light affects the color of these leaves, it is important to be aware of the direction it comes from at various times of the day and how the light is affected by the surrounding cliffs and ridges. El Capitan Meadow is an excellent example. This area can be in shadow during the early and late hours but then be illuminated

by midmorning and afternoon sun. However, due to the proximity of Sentinel Rocks, portions of the meadow may temporarily fall into shadow in the middle of the day. Late in the afternoon, as the sun drops to the west, you may find some beautiful low-angle light coming from the end of the Valley—but don't wait too long, as the formations to the west block the actual sunset.

Bigleaf maple trees: The bigleaf maple trees produce some of the most intense colors in the Valley, and the huge size of

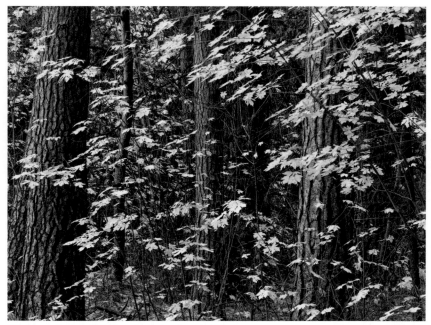

A final burst of autumn bigleaf maple color in a Yosemite Valley forest

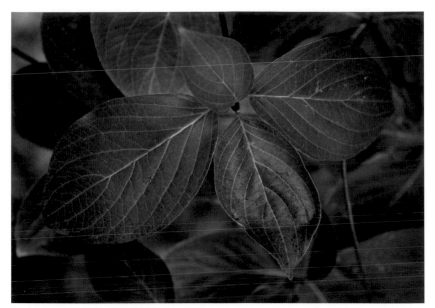

The colorful autumn leaves of a Yosemite dogwood tree

their leaves makes them even more impressive. They tend to grow in shaded and thickly vegetated areas. An excellent area to find them is where the roadway splits as you enter the Valley from the west, just above the Pohono Bridge.

Dogwood trees: Dogwood trees grow in the Valley and along Big Oak Flat Road and State Route 140 as they rise out of the Valley. These Yosemite dogwood trees are renowned for their beautiful spring flowers, but they can also produce some lovely leaves in the fall. Their often subtle colors range from yellow through pink to reddish.

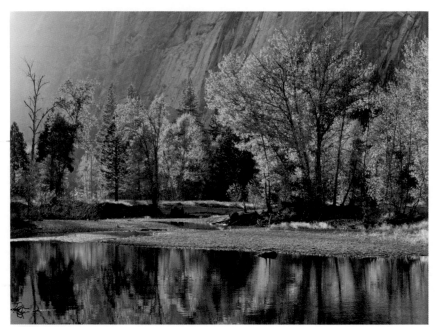

Hazy autumn afternoon light on golden cottonwood trees growing along the banks of the Merced River, Yosemite

Because their range extends from the Valley to some of the higher locations along the park's access roads, the dogwoods' color often arrives over a long period of time, beginning earlier up high and culminating a bit later in the Valley. Dogwood trees are found in many places in the Valley, including Curry Village and the former campground sites along the road between that location and Ahwahnee Meadow.

Cottonwood trees: Cottonwood trees are ubiquitous in the American West, often growing in wet areas and along streams. They range from small trees to gigantic older specimens. In the fall they produce intense yellow-colored leaves that have a shape reminiscent of that of aspen leaves.

There are large and very beautiful stands of cottonwoods along sections of the Merced River. One notable and accessible example is seen from Northside Drive as it passes through Sentinel Meadow just before the Yosemite Valley Chapel, and on sunny afternoons in the fall when the light is just right the trees along the river may glow with golden color.

The Merced River: A primary feature of the Yosemite Valley, winding along the Valley floor, the Merced River can be very special during the autumn season. Like the meadows, its treeless expanse provides open views of the surrounding features, from the forests that line its banks to the cliffs high above. Its moisture supports many plants, ranging from grasses and shrubs right up to the cottonwood trees described above.

The river provides a wide range of photographic opportunities, some of which are specific to the fall season, when lower water levels expose more of the river rocks and the water reflects the autumn colors of trees along

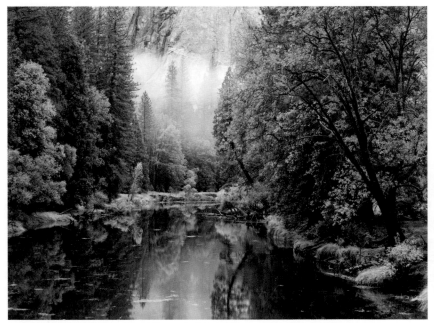

Fall color along the banks of the Merced River at the El Capitan Meadow Bridge, Yosemite Valley

the riverbanks. Colorful leaves fall into the river and float along its surface and sometimes pile up against rocks and deadwood. River rocks and the reflections of color from trees and sunlight on canyon walls create opportunities for abstract studies of form and color.

Meadows: The meadows of Yosemite Valley are special places any time of the year, from the new growth of spring to the periodic snows of winter. As mentioned earlier,

during the fall they are the place to find oak trees, but there is much more to see there at this time of year. Shrubs and brush turn color, and the meadow grasses, in typical California fashion, dry out, turn brown, and take on a beautiful warm and golden quality in the autumn light; you can find a lot of color right at your feet.

On cool mornings you may have a special treat and experience ground fog. This fog may be but a few feet deep, and it almost seems alive as gentle breezes waft it back and

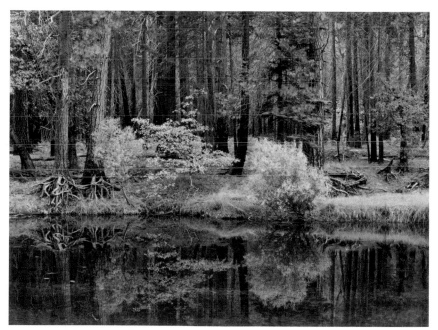

Colorful autumn trees in burned forest, reflected in the waters of the Merced River, Yosemite Valley

forth across meadows. If you want to see this special sight make sure to get out very early since it often dissipates soon after sunrise.

Fallen Leaves: When we think of fall color, we imagine *trees* full of beautiful and intense color. But leaves don't remain long on the trees. They fall to the ground—where they can also be the subject of compelling photographs. Photographers love to look for beautiful individual specimens, small groups of colorful leaves, or carpets of

Autumn colors on trees and meadows, Yosemite Valley

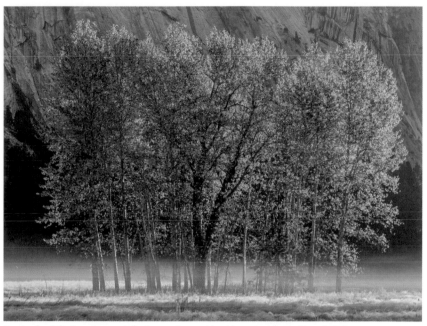

Morning fog drifts through a stand of cottonwood trees with golden autumn leaves, Yosemite Valley.

color created when winds bring down many leaves in a short period of time. Walk slowly along the Valley trails and look carefully.

Clouds, Mist, and Rain: Colorful leaves are not the only autumn subjects in Yosemite Valley. Fall is a time of transition in California when conditions gradually switch from the dry and sunny summer patterns to the winter pattern of periodic weather fronts. The first winterlike

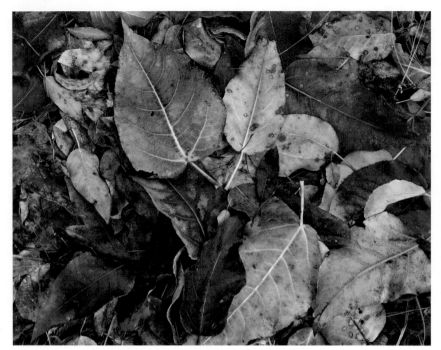

Leaves, wet from morning frost, litter the ground near the banks of the Merced River.

storm fronts often appear during the fall color season, and when a front comes through there are all sorts of interesting possibilities. Clouds and mist may shroud the upper cliffs and pinnacles around the Valley, producing dramatic sights. Rain may bring waterfalls and creeks back to life after their late-summer dormancy. A cold storm may even drop a coating of snow on the upper peaks and ridges.

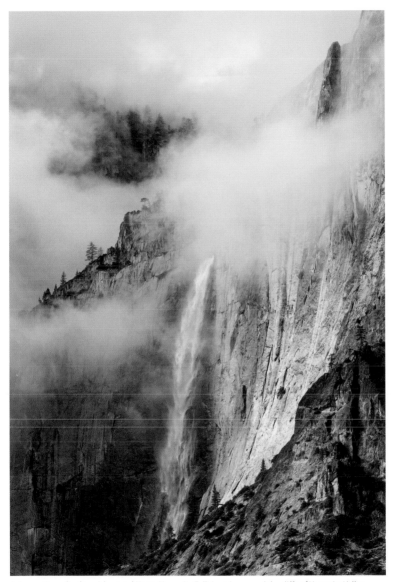

Autumn storm clouds swirl around Upper Yosemite Fall, Lost Arrow, and the cliffs of Yosemite Valley.

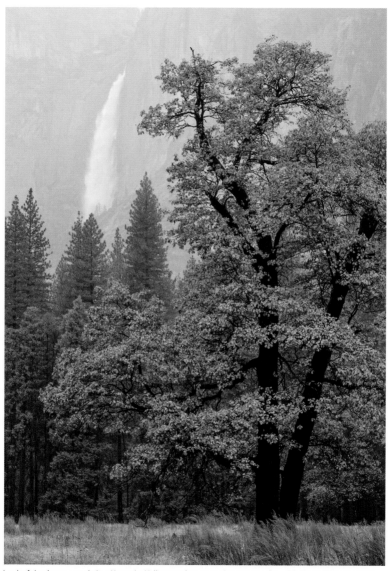

A colorful oak tree stands in a Yosemite Valley meadow on a rainy autumn day, with Upper Yosemite Fall beyond.

HOW TO PHOTOGRAPH FALL COLOR

We've all visited a spectacular location, been overwhelmed with its beauty, and made a photograph only to discover later that the picture did not convey the wonder we felt when we were there. This often happens because your camera does not "see" the same way that you do. For example, the high contrast between shadow and sunlit leaves in the middle of the day may be a challenge for your camera. Subjects that move may create motion blur. The colors of light in shadows may be amplified. A thing that draws your eyes in the actual scene may be lost in a sea of details in a photograph.

Knowing about a few technical and aesthetic issues can be useful, whether you simply want to capture your

experience to share with friends or you have aspirations of producing big, beautiful photographs.

What follows is not geared toward highly experienced fall color photographers, who probably know much of this already—though they might find a useful hint or two here. These suggestions and techniques are intended for those in the range between casual snap-shooters and serious amateurs, who might be using anything from a smartphone camera to a modern DSLR (digital single lens reflex) camera or a mirrorless equivalent. We begin with a list of objective factors and conclude with the all-important topic of composition.

Time of Day

It is possible to make interesting photographs at any time of the day, but there is something special about early morning and evening, when the color of the light is softer and warmer, and its low angle highlights textures and illuminates shadows.

Angle of Light

Your position relative to the trees and the sun can turn a boring photograph into something striking. Colors can look washed out when aspen trees are "front lit" by light

that comes from behind you. But move to the other side of the tree, so that the leaves glow from light hitting them from behind, and that drab tree can produce beautiful color. This is easiest during the early and late hours, when the sun is lower in the sky.

Quality of Light

Many photographers believe that the quality of light is the most important factor in good photographs. Once you become aware of light you recognize its power. Your subject is important, but in great light your subject can become special. Light is an element of seemingly infinite variety, and here are a few observations to get you started thinking more carefully about it:

- The color of light varies. Very early or late in the day, during the so-called golden hours, blue is suppressed and the light is warmer. Shadows lit by open sky can be very blue—so blue that you may be surprised by the effect when you see your photographs later on.

- Light picks up the colors of things that reflect it, and it picks up the colors of things it passes through—for example, light shining through or reflected from fall foliage can pick up the yellow, orange, and red colors of the leaves.

- Light can be harsh or soft. The light of midday, when the sun is high in the sky, is harsh, with stark shadows and extremely bright highlights. At dusk or in shade, when there is no single light source, the light can be soft—highlights are less contrasty and shadows may be filled by diffused light.

- In heavy overcast, the light can become flat, with almost no shadows. Subjects can lose their feeling of depth, and colors can look washed out.

- Mixed lighting, as when it is partly cloudy, may add depth to the scene, especially if the brighter light falls on an important subject and the shadows fall on secondary subjects.

Exposure

Exposure settings enable your camera to produce the best image of a scene, accounting for the amount of light and the motion of your subject and the camera itself. Modern cameras, from smartphones to DSLRs, are often used in an automatic exposure mode, where the camera analyzes the scene and sets the shutter speed and/or aperture for you. For basic photography you may not need to concern yourself too much with technical details of the three key settings: ISO, shutter speed, and aperture. However,

knowing a bit about these things may improve the quality of your photographs.

- ISO is the camera's sensitivity to light. A higher ISO value means that the camera can capture images in lower light or at a shorter shutter speed. However, increasing ISO too far can degrade the photograph, introducing noise into the image and more. In general, be cautious about raising ISO higher than necessary.

- Shutter speed is how long the camera's shutter opens to admit light. Fast shutter speeds can "stop" motion, but they also let in less light. Longer shutter speeds let in more light, but they can allow the image of a moving subject to blur, and you may not be able to hold the camera steady enough to produce a sharp image. You will usually want to keep the shutter speed short enough to avoid unwanted blur.

- Aperture refers to the size of the lens opening that admits light to the camera. The larger the opening, the more light is admitted. Aperture is indicated using "f-stop" values. Perhaps counterintuitively—and because f-stops represent fractions—lower numbers indicate a larger aperture (more light), while higher numbers indicate a smaller aperture (less light). So f/4 is a larger aperture and allows in more light than does a smaller aperture like f/16. The factors affecting

aperture choice can be complex. A middle-range aperture is often a good default choice, but consider using a larger aperture if you need a faster shutter speed or must deal with low light.

Shutter Speed and Camera Stability

We've all seen photographs that were ruined by blur, either because the subject of the picture moved or because the camera moved as the photograph was exposed. Unless you want blur for creative reasons, minimize it by using a faster shutter speed, enabling the image stabilization feature on your equipment, or using a tripod.

- When it comes to keeping a moving subject sharp enough, shutter speed is the key: a faster shutter speed reduces blur. (In some cases, you can pan the camera, moving along with the subject to reduce the blur, though this will make the background blur instead.)

- There are several ways to minimize blur from camera motion. One of them is, again, to use a faster shutter speed. It also helps to pay attention to holding the camera steady and pressing the shutter smoothly, rather than punching it. Many modern cameras have an image stabilization system—a camera or lens mechanism that detects and compensates for camera vibration and may allow longer shutter speeds.

- The classic method for eliminating camera blur is to use a tripod, which not only eliminates vibration, but also helps you carefully frame the scene.

Composition

Serious photographers give a lot of attention to composition, the process that includes framing a shot by moving the camera forward, backward, side to side, and more in order to get elements of the photograph to work well together and to eliminate distractions. This is a very big subject, and it takes a lot of practice to become proficient at composition, but there are basic considerations that will improve the quality of your photographs.

- Consider where to put your main subject in the frame: Putting a tree in the bottom of the frame with a lot of sky above may create a feeling of immense space. Pointing the camera down and eliminating the sky may focus more strongly on close subjects. Locating the tree in the center may evoke a feeling of stability, while placing it off center may create a more dynamic composition. There is no one "right" composition, but think about how your choices affect the photograph.

- Move closer: In most photographs there is a primary, most important subject. Put too much distance between

yourself and the subject and that subject may seem too small and too far away in your photograph, or it may be lost in a sea of other details.

🍂 Consider relationships between subjects: Subjects at varying distances can lead the viewer's eyes into the composition. You can highlight an important subject by placing it against a contrasting background. Lines and shapes may be juxtaposed to form S-curves or otherwise lead the eye to important elements.

🍂 Experiment with focal length: If you have a zoom lens you may shift between wide-angle and telephoto. The effect of getting close with a wide-angle lens is much different from the effect of standing back and shooting from a distance with a telephoto. Try both, and you'll notice that the wide-angle lens includes much more background, and the telephoto compresses subjects.

🍂 Experiment with aperture: Aperture is not just about exposure. It is also a way to control depth of field, the distance objects may be in front of or behind your main focus point and still appear sharp. By using the largest aperture of your lens, you can focus on a nearby subject—perhaps some colorful leaves—and allow more distant objects to go pleasingly out of focus, making your main subject stand out against the soft background. Use a small aperture to increase the depth of field and make both near and far subjects sharp.

- Eliminate unnecessary distractions: If your photograph is about a central subject, perhaps a single tree, reframe the scene to eliminate unnecessary and distracting elements.

- Check the edges: In most cases, you want the main points of interest to be away from the edges of your picture. Be careful about objects that are cut off by the frame edges.

- Minimize overlaps and awkward juxtapositions: Watch for elements in your composition that touch or overlap—it is often better to keep a bit of space between them. You probably don't want a tree to look like it is coming out of your friend's head!

- Avoid accidentally including elements that detract from your photograph: Is there litter on the ground? Do you really want that building in your photo of the trees? If you wait a moment that car may move out of the frame.

- Pay attention to the light: You probably do not want your main subject to be in shadow when everything else is in the bright sun. Small objects in the scene that are in full sun can be very bright, creating a pure white "blown-out" point in your photograph—sunlit rocks and branches are common offenders.

Embracing the Unexpected

Heading off in search of fall color, we often have specific ideas about what we expect to find—beautiful and colorful leaves, good weather, interesting skies, perfect backgrounds, and more. But things don't always work out that way. Nature is in charge, and we don't always get exactly what we were expecting. Colors arrive late or early. A storm sweeps in and blows leaves down. Early snow closes roads and renders locations inaccessible. Rain makes hiking and driving difficult. Clouds block the light.

Spend enough time in the mountains and you will encounter such circumstances. A bit of creative thinking and observation can turn them into opportunities. Don't let your focus on fall color blind you to other possibilities when they present themselves. Here are a pair of photographs and the corresponding stories of how unplanned circumstances and a bit of improvisation turned out well.

One morning, as I drove out of Bishop before dawn to photograph aspens in the area, there was just enough light to see some clouds. They appeared to be "Sierra Wave" formations, which form long and beautiful layers along the eastern escarpment, extending out into the high desert. Thinking of what sunrise light would look like on these clouds, I remembered a small alkali lake thirty to forty-five minutes up the valley, visualized a photograph of clouds from the shoreline of the lake, and changed my destination.

The light was increasing and I had no time to waste, so I headed north. Arriving at the lake, I grabbed my camera, mounted a lens, put it on the tripod, and walked quickly toward my intended position. The clouds were lining up in spectacular

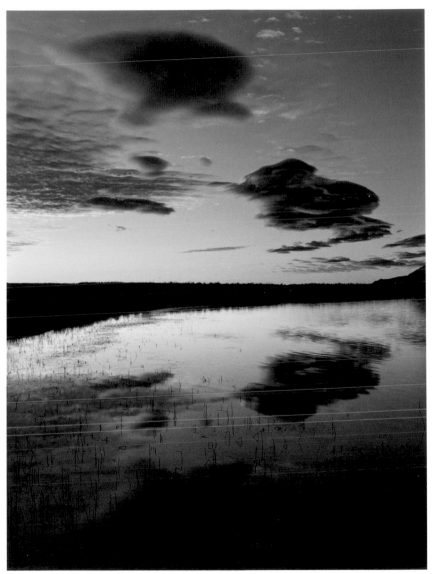

Sierra Wave clouds building at dawn are reflected in the waters of an Owens Valley lake.

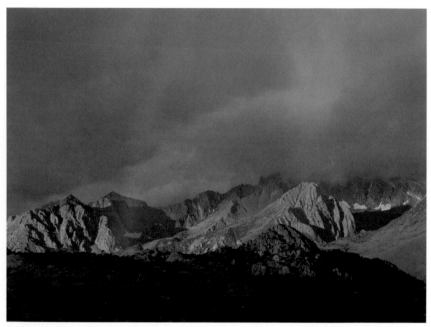

Brief sunrise light produces a rainbow and virga over the Buttermilks in the Eastern Sierra above Bishop.

form as the sun was about to rise. Within moments I was set up and had composed a photograph. When the sunlight appeared I made a quick series of exposures.

Another morning, I drove out of my campground in the Bishop Creek drainage and noticed a steady stream of headlights headed up into the mountains from Bishop. My destination was a nearby aspen grove, and these cars were likely carrying other photographers with plans similar to mine. To the east, just above the White Mountains, I saw a small clearing in the cloudy sky.

One of the most beautiful photographic conditions in the Eastern Sierra occurs when low-angle light sneaks through a gap below the clouds and a band of dawn light descends across the face of the Sierra. It is even more spectacular when there are dramatic clouds above the crest, as there were on this morning.

Once again, I already knew of a good viewpoint from previous visits. I arrived just in time, and as I set up my camera the band of first dawn light came through the gap in the clouds. On top of that, rain and snow were falling from the clouds and a rainbow briefly appeared!

I later talked to someone who had been up at my intended aspen grove that morning, and he reported that it had been cloudy and gray.

Dealing with Challenges

Fall color photography has its own set of special challenges. Let's take a look at how to handle some of them.

- Autumn foliage is often intensely colorful, and the most intense colors are the saturated reds and yellows. Your camera's metering system can be tricked by this unbalanced color. For example, a close-up photograph of very colorful leaves may contain a lot of red or yellow and almost no blue. Your camera bases its automatic exposure on the average of different colors of light and does not recognize that one is stronger than the others, thus overexposing the hot color—typically red—so that the details of your colorful subject disappear. If this happens you may need to decrease your exposure a bit.

- Wind can be a problem when photographing foliage, especially when you are working close up, or in low light, and the moving leaves create a blurred image. If the wind is variable you can wait for it to die down before you take your picture. If you do not need a lot of depth of field, use a larger aperture and a faster shutter speed. You can raise the camera ISO setting a bit. You could also work with the wind, and accept motion blur as part of your photograph.

🍂 Autumn foliage color is more intense when the light is behind the leaves. However, if the sun is shining directly into the lens it can produce lens flare—bits of unwanted light in the photograph. Using a lens hood on your camera may help, though this is not always enough. Sometimes you can block the direct sun by lining the camera up with the shadow from a tree trunk or branch or even a dense bunch of leaves. You can also use your hand or hat to block light that might directly hit the lens. If you have a choice, you can more easily control flare with a longer lens, which allows you to narrow the area included in the photo.

🍂 In the fall you may have to deal with inclement weather in the Sierra. Unless you have a waterproof camera (and most cameras are not waterproof!) you need to protect your equipment. It may be fine to work briefly in a bit of mist, especially if you can dry your gear soon afterwards. Minimize the amount of time that the camera is exposed to the elements, and try to protect it with an umbrella or some other cover. Try to find a sheltered place to make lens changes.

🍂 You won't often have to deal with snow when photographing fall color in the Sierra, but it can happen. Camera batteries do not last as long when they become very cold—bring spares and keep them in a warm pocket. Watch for lens fogging, which is often a result of moving gear between warm and cold. Minimize the

problem by taking steps to reduce sudden temperature changes. Keeping the photographer warm can also be a challenge! Besides the usual warm clothes, warm insulated winter boots are important if you'll be out for long. Keeping your hands warm can also be tricky since you probably cannot operate your camera while wearing thick gloves. Some photographers wear a thin pair of inner gloves under heavy gloves or mittens, and these are just warm enough to protect hands during a few moments of shooting.

More Tips for Photographing Autumn Color

🍂 Stop and look. Don't leave right after you make your first "Wow! Colorful trees!" photographs. Slow down and look around. What do you see that you missed at first? What other ways can you find to photograph your subject? Some photographers begin without a camera in their hands, taking time to look and contemplate before making photographs.

🍂 Move in close. Instead of shooting whole groves and whole trees, look for compositions of individual leaves, a small group of them, or a branch or two.

🍂 Look beyond the leaves. For example, when it comes to aspens, the paper-thin bark and near-white trunks and branches have their own charm, either with or without the accompanying leaves.

- Photograph leaves that have fallen to the ground. There is something beautiful about very colorful leaves littering the ground beneath autumn trees.

- Shoot the whole scene. The fall color experience includes more than just the trees. The flowing creeks, granite boulders, other nearby trees, golden meadows, towering peaks, and more can be part of the scene; including the environment of these trees brings variety to your photographs.

- Rather than rushing from grove to grove, consider "working" one grove thoroughly. For example, start in the morning in the diffused predawn light, and continue shooting as the sun comes up and lights the sky but leaves trees in shadow. Work quickly as the edge of the shadow cast by nearby ridges moves across the grove: this is a wonderful moment of beautiful light. Then see what new subjects are revealed in the direct early-morning light.

In the end, there is no single right way to photograph fall color—or any other subject, for that matter. There are many good ways to see and photograph trees and other fall subjects, and part of the fun comes from discovering your own way of doing it.

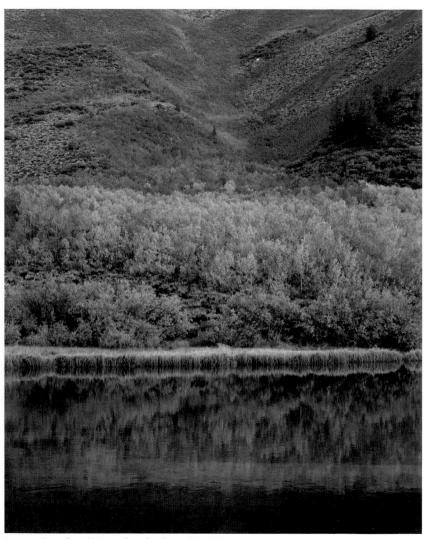

Autumn colors reflected in the surface of an Eastern Sierra lake

ETIQUETTE
AND RESPECT

In the past few years the number of photographers "chasing aspen color" in the Eastern Sierra has increased tremendously. Each of us has a responsibility to exercise care and respect for this environment that we love so much. I've never been able to understand folks who will go to great lengths to visit such astounding locations...and then trash the very places that attracted them. By "trash," I don't just mean litter—I mean more generally acting in ways that degrade the total experience of the landscape we photograph.

You and I visit these places because they are special and valuable to us, so it follows that we must treat them with respect, value their beauty, and maintain that beauty for others who will follow us there.

This is a list of a few things that I often think about in this regard:

- Don't destroy the beauties that drew you to the Sierra. If you cannot access an aspen grove without damaging the grove or the approach, let it go—there are plenty of other trees to photograph.

- It should go without saying, but don't litter. If you can carry it in, surely you can carry it out empty!

- Respect the quiet of these mountain places. As your mother said, "Use your indoor voice." Turn off that audio system in your car and join the rest of us in enjoying the precious silence broken only by the subtle sounds of wind, rattling dry leaves and grasses, singing birds, and flowing water.

- Use common sense when it comes to where you park and where you drive, especially if you have a four-wheel-drive vehicle. Avoid damage to roads and parking areas, be careful of nearby natural areas, and protect your own safety and that of others on the roads.

- Respect road and trail closures and private property.

- Think carefully about how much information you share with others and with whom you share it. This has become an important issue for me recently, so much so that I've included a section on it later in this chapter.

🍃 Do share information with other photographers on the scene, especially by speaking to them in person. An informal network springs up during aspen season as photographers meet one another in the field. Most have shot in a few other places, and they may have heard reports from other photographers. I enjoy these casual conversations, and sometimes I even end up sharing dinner with some of these people.

🍃 Be considerate of other photographers. At times it is almost impossible to avoid ending up in another photographer's shot, and at times someone may end up in yours. A bit of consideration usually goes a long way. If you see someone shooting nearby, call out and ask if you are in their shot—and if you are, conceal yourself behind a tree, rock, or bush, or try to finish up and move on. If someone walks into your shot, ask politely if they would mind backing up for a moment so you can complete your shot. If you encounter a big crowd of photographers it may be best to just move on to another subject.

🍃 Special questions arise when a workshop or class is photographing in an area where you are working. Typically, these folks are there for the same reasons you are. It is fine to be friendly, but it is not good form to hang around trying to pick up pointers from the instructor. A few workshop participants act as if they have a special right to photograph certain areas. They

don't. However, making that point too strenuously to the rare group that is out of line may not get you anywhere. Try a polite but firm approach, and if that doesn't work, simply move on and focus on your own photography.

🍃 When you talk to other photographers, try to avoid the tendency to start the conversation by talking about gear. Most serious and passionate photographers are not in the mountains to discuss the relative merits of Brand X and Brand Y, or whether a tilt-shift lens is necessary for landscape work, or whether lens A or lens B is better for photographing aspens! I'd much rather talk about...*aspens*...or your photography...or your adventures in the mountains...or getting together for dinner in Bishop or at the Whoa Nellie Deli in the evening!

Share with Care

The fall color photography scene has evolved in recent years. What changed? The population has grown, creating an increase in the number of travelers. Digital photography and new ways of sharing images have encouraged more people to pursue photography. And the Internet has made it much easier to find out about new places and subjects. It is great to see so many people attracted to the beauties

of autumn in the Sierra Nevada, but sometimes the increasing numbers of visitors can create problems.

Not too long ago we found out about places and subjects by personal sharing or by reading books—like this one! Information was not as easy to find. Today information has moved to the Internet, where nearly every photograph, article, blog post, or casual mention is cataloged and searchable by anyone, and "anyone" includes some people who do not share your deep love and concern for the Sierra. Sharing too much information about fragile places can endanger them. Share information, but calibrate what you share depending upon the risk to the place, whether it is still a quiet and peaceful spot, and whether or not it really needs sharing.

I've thought long and hard about how much to share in this book. In general, I have offered a bit more detail when the location is easily accessible, already popular, and relatively robust. I have offered much less when the area is difficult to access, fragile, or still relatively unknown and quiet. There are places that I have not mentioned at all.

Another reason to be careful about how much information you share: one of the best gifts you can give someone is to encourage them to seek out and discover their own special places. I could describe precisely where

to put the tripod for certain impressive and well-known shots, but I know that I have a deeper appreciation for places I've found on my own and which I've gotten to know over time, and I would like you to have that opportunity, too.

CONCLUSION

I remember seeing the Sierra Nevada for the first time, when I was still a child. It was shortly after my family moved to California, decades ago, and we visited the Lake Tahoe shoreline. As I grew up I became more aware of this spectacular mountain range, and I began to camp, hike, backpack, photograph, and occasionally climb there every summer and ski there in the winter.

But this is a huge mountain range and one cannot hope to fully experience every bit of it, even in a lifetime. It is perhaps not so surprising that I didn't discover the beauty of autumn in the Sierra until much later. But I did come to know it, with a bit of help from a friend who shared his passion for the east side of the range and through the viewfinder of a camera, which focused my attention on visual beauty, including the annual autumn color show.

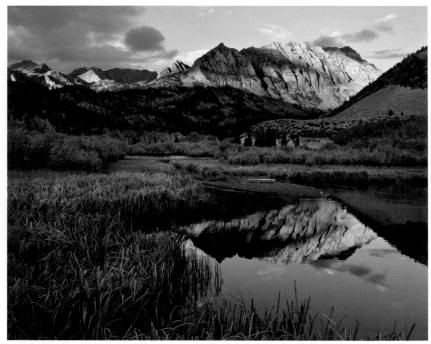

Autumn morning light on Piute Crags, reflected in the shoreline waters of North Lake

Whether you already know the Sierra and are looking to learn more about it or you are just contemplating your first exploration of the fall colors, you can discover the same autumn beauty that brings me back to the range every year. I hope you, too, will develop a deep relationship with and connection to this marvelous range, that you'll find your own personal special places, and that you will become part of the larger community of people who share this with you.

See you in the mountains!

RESOURCES AND ACKNOWLEDGMENTS

Several websites, easily googleable, offer crowdsourced information about current fall color hot spots throughout the state, including *California Fall Color* (californiafallcolor.com). The Parchers Resort "Fall Color Report" (parchersresort.net/fallcolor.htm) and Sandy Steinman's *Natural History Wanderings* blog (natural-historywanderings.com/category/fall-foliage/) also are good sources of information. The *Sacramento Bee* seasonally reports on fall color. Inyo and Mono Counties offer a handy, free map of fall color must-visits, downloadable at monocounty.org/fall-colors/ and other sites. The Bishop Area Chamber of Commerce site, bishopvisitor.com, is also a good resource. Michael Frye's *Photographer's Guide to Yosemite* (Yosemite Conservancy, 2012) offers a wealth of detailed information about photography in Yosemite National Park.

If you want more structure to your fall color experience, consider participating in a workshop. Search online for "California fall color workshop" and you'll see how many options you have. Look for a workshop that focuses on your needs, whether you are looking for a guide to locations, basic information on how to use your camera, help with composition and creative issues, or advanced technical instruction. Visit my website (G Dan Mitchell Photography, gdanmitchell.com) for workshop announcements and recommendations.

My website also features my photography, photography advice and stories, equipment reviews, and a "deals" page with special offers on photography equipment. Information and updates about Sierra Nevada fall color can be found there, at www.gdanmitchell.com/sierra-nevada-fall-color.

Thanks to Heyday for working with me to bring this book from concept to print. Special thanks to Gayle Wattawa for helping me streamline and focus the concept, words, and images; to Jeannine Gendar for skillful editing; to Art Director Diane Lee; and to designer Ashley Ingram.

ABOUT THE AUTHOR

Photographer and visual opportunist G Dan Mitchell has lived in California since the age of four. He recalls that among his first photographs was one he made of North Dome after scampering off the Vernal Fall Trail during a trip to Yosemite Valley with his family when he was a preteen. Inspired by photographs by Adams, Porter, Weston, and others, he began carrying cameras into the Sierra backcountry at the age of sixteen, and since then he has continued to hike, ski, and occasionally climb throughout the Range of Light. The natural landscape is a major focus of his photography, but he also photographs the human landscape. Visit the G Dan Mitchell Photography website: www.gdanmitchell.com.

Photograph of G Dan Mitchell courtesy of Charles Cramer. Used by permission.

HEYDAY
into California

About Heyday

Heyday is an independent, nonprofit publisher and unique cultural institution. We promote widespread awareness and celebration of California's many cultures, landscapes, and boundary-breaking ideas. Through our well-crafted books, public events, and innovative outreach programs we are building a vibrant community of readers, writers, and thinkers.

Thank You

It takes the collective effort of many to create a thriving literary culture. We are thankful to all the thoughtful people we have the privilege to engage with. Cheers to our writers, artists, editors, storytellers, designers, printers, bookstores, critics, cultural organizations, readers, and book lovers everywhere!

We are especially grateful for the generous funding we've received for our publications and programs during the past year from foundations and hundreds of individual donors. Major supporters include:

Alliance for California Traditional Arts; Anonymous (6); Arkay Foundation; Judith and Phillip Auth; Judy Avery; Carol Baird and Alan Harper; Paul Bancroft III; The Bancroft Library; Richard and

Rickie Ann Baum; BayTree Fund; S. D. Bechtel, Jr. Foundation; Jean and Fred Berensmeier; Berkeley Civic Arts Program and Civic Arts Commission; Joan Berman; Nancy Bertelsen; Barbara Boucke; Beatrice Bowles, in memory of Susan S. Lake; John Briscoe; David Brower Center; Lewis and Sheana Butler; Helen Cagampang; California Historical Society; California Indian Heritage Center Foundation; California State Parks Foundation; Joanne Campbell; The Campbell Foundation; James and Margaret Chapin; Graham Chisholm; The Christensen Fund; Jon Christensen; Cynthia Clarke; Community Futures Collective; Lawrence Crooks; Lauren and Alan Dachs; Nik Dehejia; Topher Delaney; Chris Desser and Kirk Marckwald; Lokelani Devone; Frances Dinkelspiel and Gary Wayne; Doune Fund; The Durfee Foundation; Megan Fletcher and J.K. Dineen; Michael Eaton and Charity Kenyon; Richard and Gretchen Evans; Flow Fund Circle; Friends of the Roseville Library; Furthur Foundation; The Wallace Alexander Gerbode Foundation; Patrick Golden; Nicola W. Gordon; Wanda Lee Graves and Stephen Duscha; The Walter and Elise Haas Fund; Coke and James Hallowell; Theresa Harlan and Ken Tiger; Cindy Heitzman; Carla Hills; Sandra and Charles Hobson; Nettie Hoge; Donna Ewald Huggins; JiJi Foundation; Claudia Jurmain; Kalliopeia Foundation; Judith Lowry and Brad Croul; Marty and Pamela Krasney; Robert and Karen Kustel; Guy Lampard and Suzanne Badenhoop; Thomas Lockard and Alix Marduel; Thomas J. Long Foundation; Bryce Lundberg; Sam and Alfreda Maloof Foundation for Arts & Crafts; Michael McCone; Giles W. and Elise G. Mead Foundation; Moore Family Foundation; Michael J. Moratto, in memory of Major J. Moratto; Stewart R. Mott Foundation; The MSB Charitable Fund; Karen and Thomas Mulvaney; Richard Nagler; National Wildlife Federation; Native Arts and Cultures Foundation; Humboldt Area

Foundation, Native Cultures Fund; The Nature Conservancy; Nightingale Family Foundation; Steven Nightingale and Lucy Blake; Northern California Water Association; Ohlone-Costanoan Esselen Nation; Panta Rhea Foundation; David Plant; Jean Pokorny; Steven Rasmussen and Felicia Woytak; Restore Hetch Hetchy; Robin Ridder; Spreck and Isabella Rosekrans; Alan Rosenus; The San Francisco Foundation; Toby and Sheila Schwartzburg; Sierra College; Stephen M. Silberstein Foundation; Ernest and June Siva, in honor of the Dorothy Ramon Learning Center; Carla Soracco; John and Beverly Stauffer Foundation; Radha Stern, in honor of Malcolm Margolin and Diane Lee; Roselyne Chroman Swig; TomKat Charitable Trust; Tides Foundation; Sonia Torres; Michael and Shirley Traynor; The Roger J. and Madeleine Traynor Foundation; Lisa Van Cleef and Mark Gunson; Patricia Wakida; John Wiley & Sons, Inc.; Peter Booth Wiley and Valerie Barth; Bobby Winston; Dean Witter Foundation; Yocha Dehe Wintun Nation; and Yosemite Conservancy.

Board of Directors

Getting Involved

To learn more about our publications, events, membership club, and other ways you can participate, please visit www.heydaybooks.com.